MW01278619

For Theela —
Best —
John
g.00

ISBN 1-887123-42-3
Co-published by Jabbooks and Granary Books

Distributed to the trade by
D.A.P. (Distributed Art Publishers)
155 Avenue of the Americas, 2nd floor
NY NY 10013
orders 1 800 338 BOOK

Printed and Bound in the United States of America

Granary Books
307 Seventh Avenue, #1401
NY NY 10001

Jabbooks
110 Warren Lane
Charlottesville, VA 22901

© Copyright 2000 Jabbooks and Johanna Drucker

Night *Crawlers*

on the **WEB**

*J*ohanna *D*rucker • JABBOOKS 2000

A clammy chill, tight and tactless as a deadman's, gripped the predawn terrain. Darkness squatted on thick fat haunches smothering the least hope of light out of every last crevice of the scape. Platform-independent, the circuit fields snapped with random static, restless as adolescent felines in first heat.

Necrophilic data hogs snuffled through dead files. They raised a stinking cloud as they worked. Cast-off chips, dry as feathers from an ancient burst bolster, churned upward with fury, only to sift their ashes back with uncanny slowness onto the monochrome scene.

Crude snorting ruffled the immaterial air as the hogs probed the piles. Fetid strings of broken links clung, making fragile dandruff on their pelts, as they searched bit by bit for snippets of usable code.

Huddled against the cold, spark swallows held back their piercing cries, waiting for the electric light to flesh them from their shadows.

Then the first finger of a soulless dawn broke across the airless space, touching everything in its path with the same

grasping instinct for relentless revelation. The rough outline of the hogs' anamorphic forms projected one shaggy carcass after another against the blue horizon with inelegant grace. The rhythmic crunching of their front end processors pulsed steadily.

Without motivation, one churly creature's amorphous bulk swayed too close to a neighbor's vague domain. The threatened hog skewed from its low-level browsing mode, freaking the field with a charge. Circuits glowed. The aggressor registered the violation with a muscular spasm; its

bristly mass shuddered and contracted like an old man's back from a blow. Dim perceptual threshold registers recalibrated slowly. With sluggish equilibrium the beast re-formed itself into a quiescent mass. The cautious porcine units lurched in clumsy solidarity. The odd unspoken instinct of their herd sensibility eased them into a docile configuration. Grazing beasts in a passive cycle of the scape. The fuzzy logic of the domain satisfied its anxious watchdog self that survival constraints were reestablished and went back to sleep. The lazy feedback loop sent up a steady snore, full of glottal stops and palatal rumblings.

For a moment all was halcyon in the algorithmic landscape, the peaceful pulse of circuit cycles broken only by an occasional electronic fart from one of the hogs. Against a luminous fire wall a pair of two-toned spiders, nimble by contrast to the hogs, snatched at their prey, juicy chunks of cast-off program that suffered the humiliating misnomer of "bugs" in the crude vocabulary of the carbon culture.

Neither light nor darkness was essential to the guts or being of the scape. There was no primal separation of heavens and earth, no rupture of good and evil, just the ongoing

unstoppable processing of code spinning its replicant networks to the furthest reaches of the recombinant possibility inherent in its initial public offering. An illusory hum, pitched high as an old transformer's whine, set up a neutral tone across the full curve of the mewing sine and cosine crags that defined the audio portion of the scene.

Suddenly—a spike cracked a lightning charge. The peaceful scene fractured into frightened pixels. A virulent green figure snaked across the achrome netherworld, etching its angular form into the collective perceptual parameters with a terrifying heat. The spiders went into defrag mode and withered, their fragile contingencies fried. The hogs snorted and fled, too dim to create order out of high level particles. Data ash hovered in embrace of their absent forms, then sunk obliviously onto new compiler paths.

Glowing with neon bile, the figure coalesced in a cheap slime around a config.personae. "Suck the electrons from their feeble sockets!" he cried, this frenzied anti-hero of the e-world. Elleott Eego, angular and dramatic as a new age rock star, strode to center stage of temporary coordinates. Hair streaked with stolen light, he screamed, "Tear the little

charges from their motherboards for me and let me drink deep of their sweet electric souls!"

His minions swarmed around him, eager crawlers, relentless and ruthless. The suction magnets in their workings drew them with deadly accuracy to the primal force. They had a vampiristic disregard for the niceties of protocol, seeking code in its purest forms. Elleot threw back his head, mouth wide, full lips sparking in the bitter night, and swal-

lowed. The field went dim, flickering faintly for a moment before even the lowest level of electric life faded from its circuits. Only a gasping scratching sound recalled the life being torn from the heart of the scape.

Elleot screamed. Hideous pleasure possessed his frame. His hips swivelled in imitation of an ancient reptilian performance artist. His minions ate through the fleshless field with the energy of rabid termites, gathering electrons for the insatiable master. His laughter streamed violently, scorching the parallel ports. Somewhere a firewire began to smoke and the hand of an alternate universe diddled with the keyboard in a feeble attempt to modify his profile.

The Users began to make their presence felt. Mary23.B from Virginia wrote, "heavy metal" in the space provided for musical preferences. Elleot's face gleamed. Chas. de. man @South Fork put down "soft rock" and Elleot eased his screeching pitch. Then his features hardened again as Puffcake-down-South slotted in an extra percentage of "back country" and sliced through the categorical distinctions between hard sounds and a twisted passion.

A hand, strong, delicate and elegant in its dextrous rate

of input, hesitated for a moment. The flesh digits hovered, waiting to read the effect of the latest reconfig.exe command. Elleot's operator froze and the monopersonae went rigid, his angles pushed just a little too far by the manipulation of his curves. Impulses from an external joystick breathed new life into the boy so that he wriggled with vulgar pleasure and soared once more into a spasm of contrived delight.

In the shadowy architecture of the scape the hogs were reduced to pathetic gaussian blurs, vestigial figures flattened into n-dimensional inactivity. Only the spark swallows still dove, their tracer tails swift, bright, and very ephemeral. Optimistic streaks across the weary artificial sky.

"Browser standards, all excel," crooned Elleot to the bitstream chorus. He swirled, modulating his output devices disjunctively. Signals clashed. Metal simulation smashed against raw current, a wave of garbage sound crashed uncushioned against the hard edges of his profile. The system struggled for integration and gave up. The noise level soared. "That's my last webdream, painted on the wall —" he screamed, flagrantly betraying tradition, "looking as if it

9

were alive — I call — the handling superb —"

""Can't somebody — body — body —"" an echo trailed, ""sssshhhut him UUUUP!"" A jittering parallel processor struggled to catch hold of an errant file. The voices of the user chorus rose over the snuffling action of the flat mass of hogs. Mary23.B, bored by the program, shut down and went to chase flies off her pets. Chas.de.man, persistent, had moved on to the next set of preferences and entered a long list of favorite foods, colors, and afternoon diversions to his shopping cart. Buckster.Poughkeepsie had logged on and was impulsively adopting a new scenario of gloom, letting it slide over his afternoon like slow oil on a roadside dump. The mood flickered under his influence. The swallows repeated their curve patterns of loss and renewal, the unhesitating tracery of their electron trails spelling out immaterial messages against a gunmetal backdrop that was not sky.

Elleot struck a pose on the holodeck, spreading his legs and gyrating in synch with his own motion detector. A bank of pseudo-monitors tracked his every step, the eager beavers of the input rank. A horde of input profilers contributed each their share of evidence, betting competitively to beat the

monitors at their own game. Elleot grinned until his face stretched wider than it was high. His rubber mug laughed in the mirror of its own display mechanism, defying the laws of flesh.

Mice, hands, tablets, digits all recalculated their reply. Emma in Albuquerque suggested romance; her contribution tipped the scales. From the infinite wings a second figure broached the scene. The network hummed a blind collective tune, parcelling and parsing the many bits into a general profile. Buck, bored with the sappy line, uplinked to another zone; Emma's coefficient soared. Sally, Suzie.ab181, and Sav@nnah activated their accounts simultaneously in a rush

of hormonally charged lust of a very delicate variety. The fig-
ment phantom of emerging collectivity slunk onto the scene
with a sexy innuendo to her post-nubile form.

Elleot, always eager to show off, struck his best boy pose.
Through the tight fabric of his clothing every skinny inch of
him glowed with aesthetic self-satisfaction. Built for replica-
tion, not procreation, he had no anxieties about equipment
or performance. Display was a mode of conversational un-

dress he indulged in, eager to flash his smarmy self into the headlight gaze of any new arrival.

"Come to me, my analytic heart throb," he whispered.

The slippery phantasm of collective imagination returned his inquiry with a query of disbelief. "Say what?" came the frank reply as the rapidly reformulating figure coalesced for a brief moment into a recognizably female frame.

"Lemme dialogue with your analogue, my sweet," Elleot urged. The sophisticates in the user group groaned. Elleot's operator recalculated his trajectory and waited for the buffer to clear its proverbial throat.

A fuzzy browser breezed by, disturbing the still unformed figure from its tentative configuration. A soft shadow cast itself on Elleot's brow. He hesitated for an instant, then replayed a loop in his repertoire. His sinewy lines snaked with conspicuous abandon across the oscillating plane of vision, a snake more wormlike than slick, vibrating with a repulsive slickness. No one in particular was watching. But the capabilities for invention were increasing moment by moment as the data file swelled on a rush of input factors, a thick sausage of new information ready to burst its casing

and transform.

"can he?"

"will he"

"shall we — ss-she?"

A vague sentence — sentience — spoke itself in silent rhythms in the lipless service of conjoined solicitation. A minor miracle began to stir, smoking slowly as its higher order processes wafted upward from the surface of the consciousness pool. Mary23.B had returned, bringing her edgy attitude into the mix.

Elleot gyrated slowly from his central node of vector force, letting the beziers define one point of swivelling connectivity after another. Awkwardly sexual, his movements thrust his ego into this netherworld with the swagger of naughahyde passing as leatherette on a cheap bar stool. His real world other, absent for the moment, would have been proud.

A cautious dance of sorts began. Veils of possibility, propositional statements, layered on each other to create a diagrammatic instanciation, a mazelike fretwork lit from within, spun threads of bright invention reframing the fe-

male form. Elleot extended an ungraceful hand to the still inchoate phantom. Suzie.ab181 and Sav@nnah input a mass of specifics, writing their own scenarios of seduction into the shared scene.

"Be mine," whispered Elleot, an improbable Romeo to this as yet intangible sweetheart. Desire pulsed with importunate insistence, a crude arrival to the scene. A charge snapped. A light cracked. The transfer of interest from one personal account to another lit up the screen. In a parody of some famous Frankensteinian moment, or some vision of Adam and his god, the streak of virtual lightening found its mark.

""Aaahahhhhhhhh"" the form coalesced in response to Elleot's profoundest wishes. Sweet companion to his unsa-

vory dreams, she (for it was aligned according to the gender polarities of yore) defined her boundaries and blinked, eyes wide in a face still fresh from its mail merge operation. A fine recombinant figure she made, taut against the murky netherworld of unbound energy and fallen analogue remains.

Elleot was smitten, needless to say. But he'd been programmed to respond in excess of any permissible norm, the libidinal driver in his avatar unit tuned to a fever pitch and wagging right out the trap door of his outfit. He fawned. He moaned. He wrestled with politesse and lost. His face, such as it was, turned violent with longing. Mary23.B found this repulsive, but the Buckster was upping the quotient of aggression. The attitudinal norm created a female in the role of Bride, symbolically virginal though actually experienced, and swathed in nuptial garments like some pupal moth about to burst the bounds of repressed creation. Veils like bondage gags stretched the virtual flesh taut, secondary sex characteristics bulged with cartoon exaggeration against the gossamer tissue. Suzie's fantasies were dark and wet, but Savannah set a lighter tone. The Bride glowed, taking a

wholesome pleasure in her perverse condition, her primrose glow blushing the circuit.

A horizon of opportunity spread its vistas wide to the logged-on crowd. Variants flickered like cheap lighters across their screens, while the Bride took on the well-maintained glow of afterlife. Paler than a faded cathode ray, she was reborn and redrawn continually, a mass of vector forms and pixel shades. The ravenous nighttime sucked the airless space around her, creating a virtual vacuum without space for a pixel inbetween its joyless action and her svelte form. Elleot's heart poured across the dark vortex and fed on the data rich dowry secreted among her many files and directories. The thick waters of the virtual soup swarmed with imagined lifeforms. A massive erotic discharge awakened Elleot's craven appetite springing it out of bounds. The collective audience responded, each according to their abilities, and were rewarded each according to their needs. The perverse synergy rushed the shared circuits of exchange, forging a fertile hybrid dream, shared illusion of desire, that broke them all into a shared simulacral sweat.

And then the Worms came.

Hulking and intense, their ribbon frames rose from the
variant functions operating in the electronic field, so many

humps of thick slime working their lumpen profiles across the detailed data that etched the schematic outlines of the scape. They were the dark pulse of an emergent force. As sentient as electricity and as unstoppable as tragic drama, their inevitable presence swelled into the scene with a consuming tidal wave of fearsome suction. Boring down and up and into every configured entry in the field, they created hideous holes in the illusory image of the frenzied, bridal, bacchanal.

Elleot's minions reappeared, swirling through the ion-rich atmosphere. They abandoned themselves to the surplus consumable current, drunk on insubordinate electrons, careening wildly with random access to the scene.

The Worms, doing their damnable duty, crawled through the last vestiges of decomposing con.figs and .execs. Elleot, backed up to a firewall by their bloated buffers, turned pale and began to seep from his protocol parameters into an unsorted bundle of bad code.

The recombinant Bride, swung by the virtual hand into an even more virtual space, flung back her phosphorescent veil with one pale gesture and disappeared into the collective profile without a trace. Almost. The streaking pixel

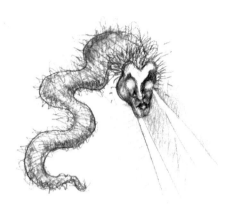

stream lingered just ever so slightly across the charged field, only long enough for Elleot to sniff its vanishing outline and sigh. Nostalgia cost him nothing. His emotional edge adjusted slightly in the histogram according to which his relationship boundaries were set, but his style value score remained unchanged. He sluffed his recent heartache into the recycle bin and rewrote his disk space, challenging the most sensitive calibration to detect the smallest error anywhere.

"I'm me," he thought, "Still me." And with this reassurance muttered mantra-like beneath his supposed breath he

went through a rapid re-sort function and uploaded himself into code storage.

The hogs came back, grateful for a fresh load of dumped files to slake their parched throats. A few bright spiders

pirouetted in their corner of the web, happy for the swill-bits that came from the emptied cache. And in the thick data-mass, the generative substrate of the scape, an eager host of newly launched little crawlers kept up their steady efforts at disintegrating the infrastructure of sustainable systems.

By the time Elleot was called back by his otherworld operator, the game had changed enough to be interesting. The beloved Bride was nowhere to be found. How could she be? Manufactured by a temporary configuration of consent, her particulars had redistributed themselves for reuse. Even memory, with its fragile formalisms, could not conjure her again.

The data hogs had churned the cast-off remnants of the Bride, swilling the cast-off info into fodder for their deep intestinal mill.

The Worms withdrew into the safe harbor of deferred expectations and waited, in a condition of vigilant latency between wakefulness and slumber. Recumbent, their slack rope shapes lay ready to awake and strike whenever the surge was sufficient.

The twilight settled back comfortably into place, the famil-

iar fit of its old sweater dullness blurring the last lines of bi-narisitic distinction. Difference subsided into a vague notion of sameness while the flashlight-eyed night crawlers continued their relentless effort to classify all strings of code. With patient filing skills they ordered and reordered the virtual universe, momentarily, again.

Over it all, an unanticipated sentience lurked at the out-skirts of the scape, its dimly dawning slice of self-reflexive insight pulsing just slightly at the edge of its own awareness.

The Worms turned and hesitated, formless bodies swelling into bulbous purposeful shape. Hungry for the surge on which they fed, they contracted momentarily, cautiously waiting for the right window to open among dispar-ities of power. The spark swallows swept through the field, their sharp cries registering a futile protest against the life-less air. The cold came back, dark and cheerless, waiting to be rewritten by sections of new code.

Ahead of the curve, at the threshold of the refresh rate, a slick little Solipsism slipped into the zone. A dark cool stranger, riding bareback into the damp dawn of their col-lective desires. On the always faint horizon, coming newly

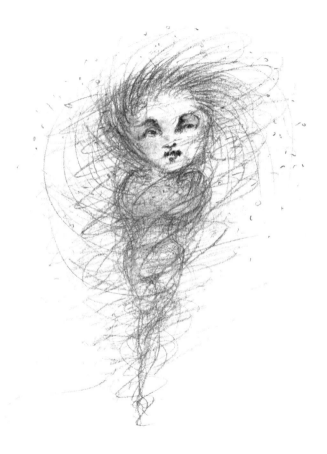

into focus, this flickering plasma harbinger of the next drama began to take shape, her nimbus rising on the halfshell created by a vague consensus of input. Elleot gazed with appropriate wonder, his jaw slack, eyes half shut in his reptilian pose. The splendid new framework of collective imagination thrust upward across his coordinates of perception like a primal thundercloud of hope and desire. Ever ready, he felt as eager as a kid in a game arcade. He paused, to give the appearance of suave reserve, while his cheap libidinal instincts ran ahead of him through a random access onramp to the fastpaced highway of imagined romance.

The urgencies of immaterial desires raced to center stage. A trick of light — or was it life? — focused attention on the new arrival. Everybody's heads turned. Even the worms. Some-thing amazing was about to happen. The metaphysical sentience glowing at the edges of almost everything would have to wait its turn in the processing queue.